Really GRIMM'S Doodle Diaries

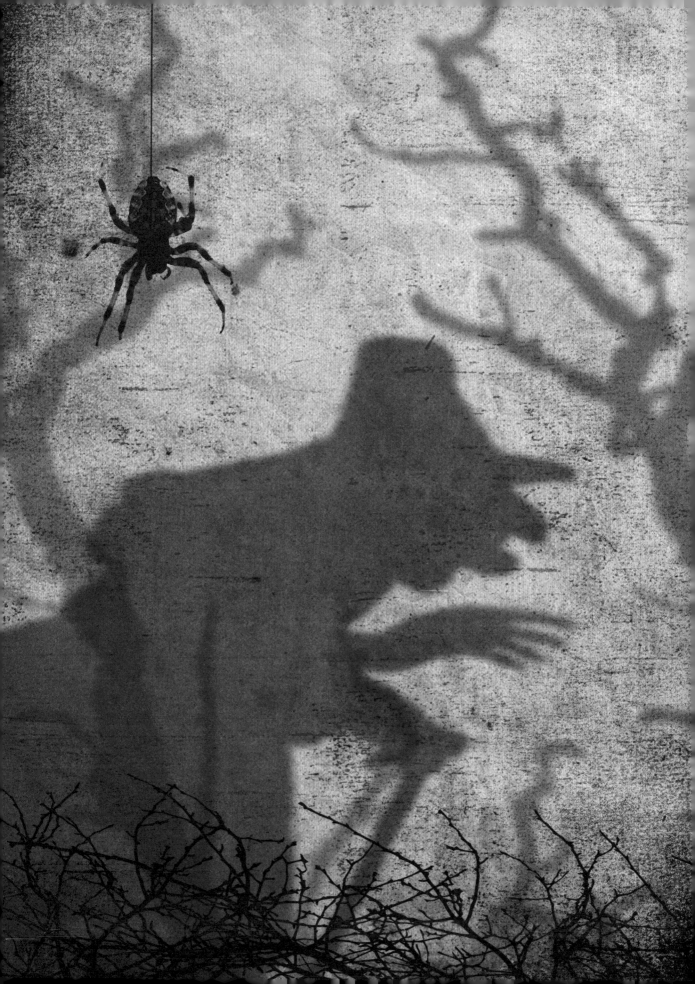

Really GRIMM'S

Doodle Diaries

THUNDER BAY
P·R·E·S·S

San Diego, California

THUNDER BAY PRESS
An imprint of the Baker & Taylor Publishing Group
10350 Barnes Canyon Road, San Diego, CA 92121
www.thunderbaybooks.com

This book was conceived, designed, and produced by Paperwasp, an imprint of Balley Design Limited, The Loft, 45 Grantham Road, Brighton, East Sussex, BN1 6EF, UK.
www.paperwaspbooks.com

Creative director: Simon Balley
Designer: Kevin Knight
Text: Simon Balley
Project editor: Kathy Steer
Illustrations: Kevin Knight

ISBN-13: 978-1-62686-253-1
ISBN-10: 1-62686-253-2

Printed in China.

1 2 3 4 5 18 17 16 15 14

IMPORTANT NOTE—There are many activities in the book that you can cut out or just simply use as a template guide on either paper or card.

See IMPORTANT NOTE symbol at the end of these activities before making your final choice.

!

THIS BOOK BELONGS TO ...

The woods can be a scary place if you are truly lost!

A large creaky tree stands before you—old wooden frames clatter in the gentle breeze.

Now doodle in as many characters from your favorite Grimm's stories and complete your Family Tree.

NOT A WORD!

Now try and unravel the secret words hidden in this simple word search puzzle below. I've started you off ...

```
c u h t a s v r s s p u
e i y t m e p a n n v t
f m n m c i o p e a i t
u j i d p m c u v k x v
a r k e e h s n a e s r
g y r e i r l z r x e n
t h j m c u e e s r a u
z h n a m n y l g e c g
l e s n a h i z l e k w
y m o t h e r r s a n m
f l o w q f y l p z o d
z b a y p n h s a f p b
```

chimney legend Rapunzel
Cinderella mother ravens
wolf piper snake
Hansel prince Grimms

8

Draw something horrid here!

9

GET LOST!

Find out who will survive the terror of the deep dark woods!
Will Little Red Riding Hood safely meet her grandmother?

Can the woodcutter seek out the nasty wolf in time?

Follow the tangled lines and discover their fates for yourself.

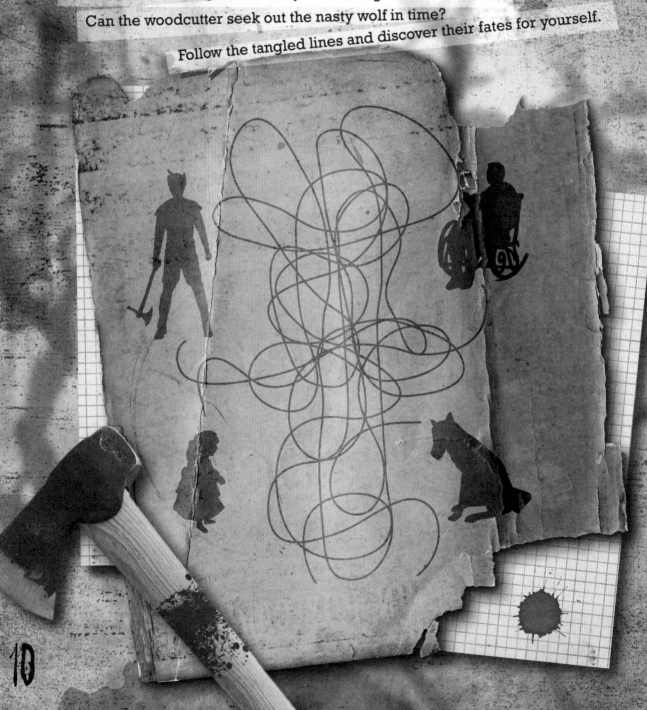

My top 10 Grimm's stories of all time!

Start your list here ...

1.

2.

3.

4.

5.

6.

7.

8.

9.

10.

DON'T HANG AROUND!

Challenge your friends to this great hangman game,
and guess what Rapunzel's secret words might be...

DRAW YOUR HANGMAN HERE

ENTER YOUR WORD HERE

can be up to 11 letters

_ _ _ _ _ _ _ _ _ _ _

ABCDEFGHIJKLMN
OPQRSTU
VWXYZ

CROSS OFF THE
DEAD LETTERS

12

ABCDEFGHI
JKLMN
OPQRSTUVWXYZ

It is dusk and the old grandmother has left her wooden spinning wheel alone.

Design some embroidered messages to warn her of the dangers hiding in the woods!

ABCD EFGH IJKL MNO PQRS TUVWXYZ

BEWARE!

example idea

13

NO HANDSOME PRINCE!

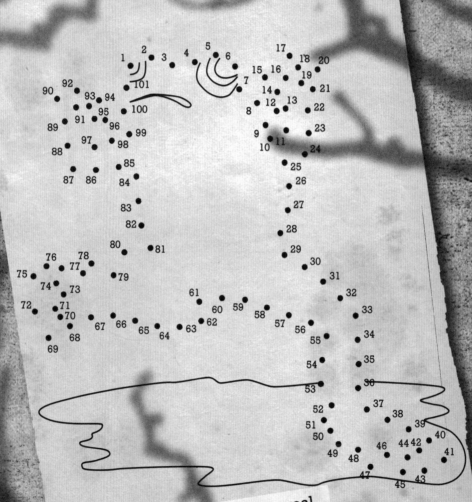

Connect the dots to reveal
who the princess
will be kissing ...

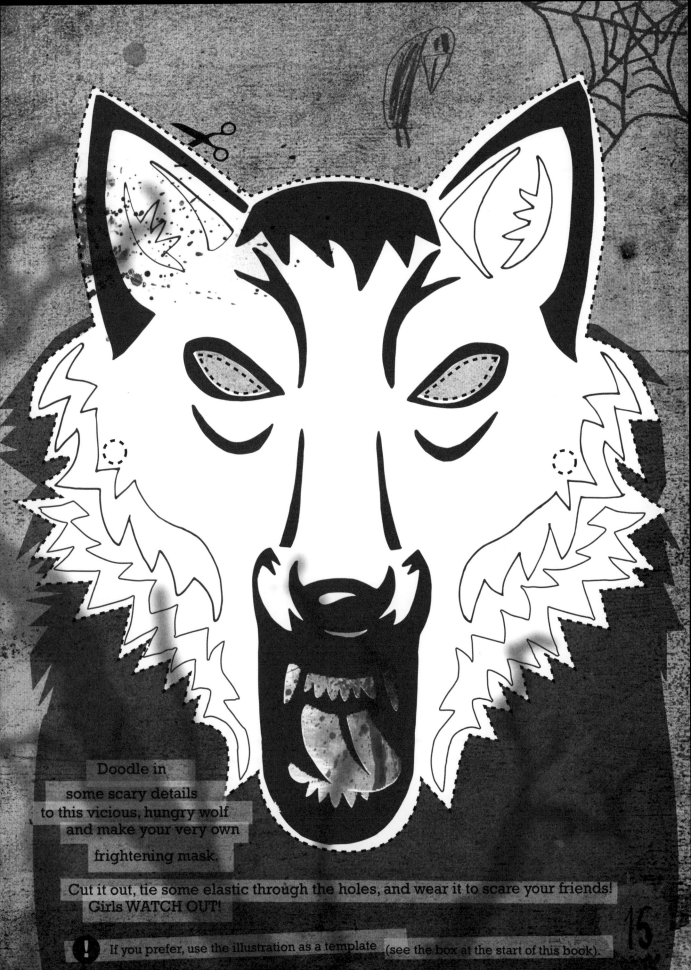

Doodle in some scary details to this vicious, hungry wolf and make your very own frightening mask.

Cut it out, tie some elastic through the holes, and wear it to scare your friends! Girls WATCH OUT!

If you prefer, use the illustration as a template (see the box at the start of this book).

15

ABCDEFGHIJKL
MNOPQRSTUVWXYZ

Place a mirror here to reveal
your sinister message.

You must warn the
poor woodcutter's

two children,
Hansel and Gretel,
of the perils of
walking alone
in the thick,
dark forest!

Draw in your scary
backward message
on this old bit
of useless paper.

WATCH OUT

Don't forget to color it in!

WANTED
DEAD OR ALIVE

Doodle in a picture of your most wanted Grimm's character and complete this great poster. Choose something from your favorite stories, such as Snow White's evil stepmother, or the wicked witch.

BE CREATIVE!

DOUBLE TROUBLE!

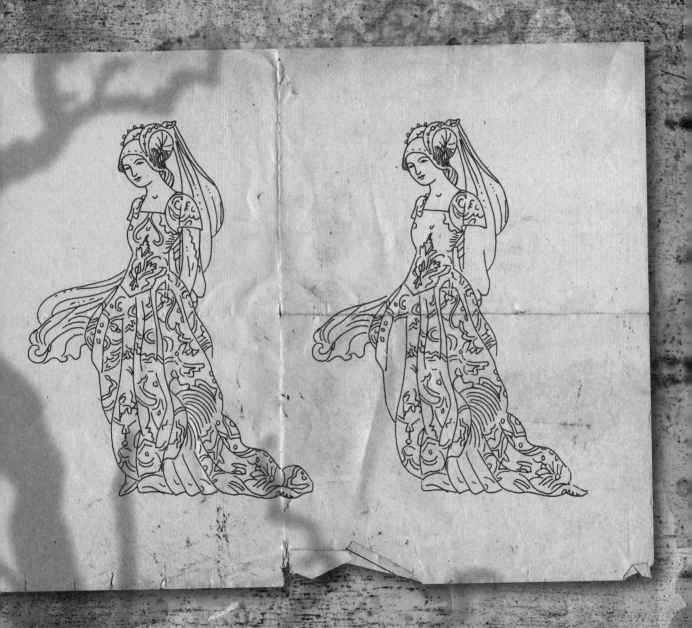

Try spotting the six differences between these twins.
Look carefully into the detail, and then circle your findings with a pencil.

THE THREE RAVENS

Carefully cut out these ravens to create your own scary hanging mobile.

Look for a small length of scrap wood as shown below and hang these at different lengths for a great effect!

Cut a hole out for the eye and thread your string through the hole.

DON'T GET IN A FLAP!

If you prefer, use the illustrations as a template (see the box at the start of this book).

THUMBS UP!

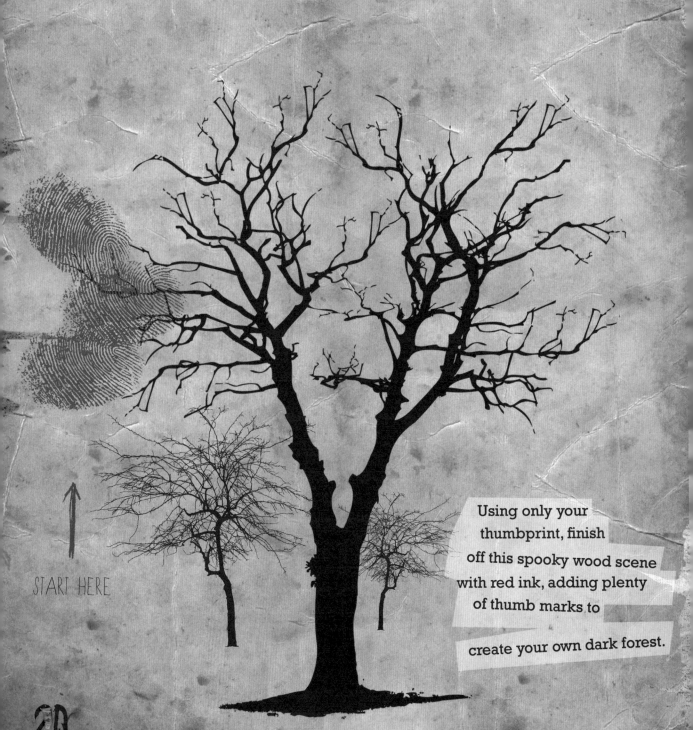

START HERE

Using only your thumbprint, finish off this spooky wood scene with red ink, adding plenty of thumb marks to

create your own dark forest.

20

PAPER CHAIN

It's simple!
Here's what to do ...

First, cut a long strip of paper.

Fold the paper like an accordion, wide enough to draw your witch outline.

The number of folds depends on the length of your paper, but each fold represents another witch so the longer, the better!

Now, draw your outline at one end of your strip of paper. Make sure the head touches the top edge and the feet touch the bottom edge, and the same with the hands and skirt touching the outer edges, as shown opposite.

Trim off any leftover paper that is not wide enough to fold. Now, cut out the witch leaving only the folds intact at the hands and skirt (side edges), so the chain does not break.

Unfold the paper to reveal your chain of witches!

Use this stencil for your scary witch paper chain.

! If you prefer, use the illustration as a template (see the box at the start of this book).

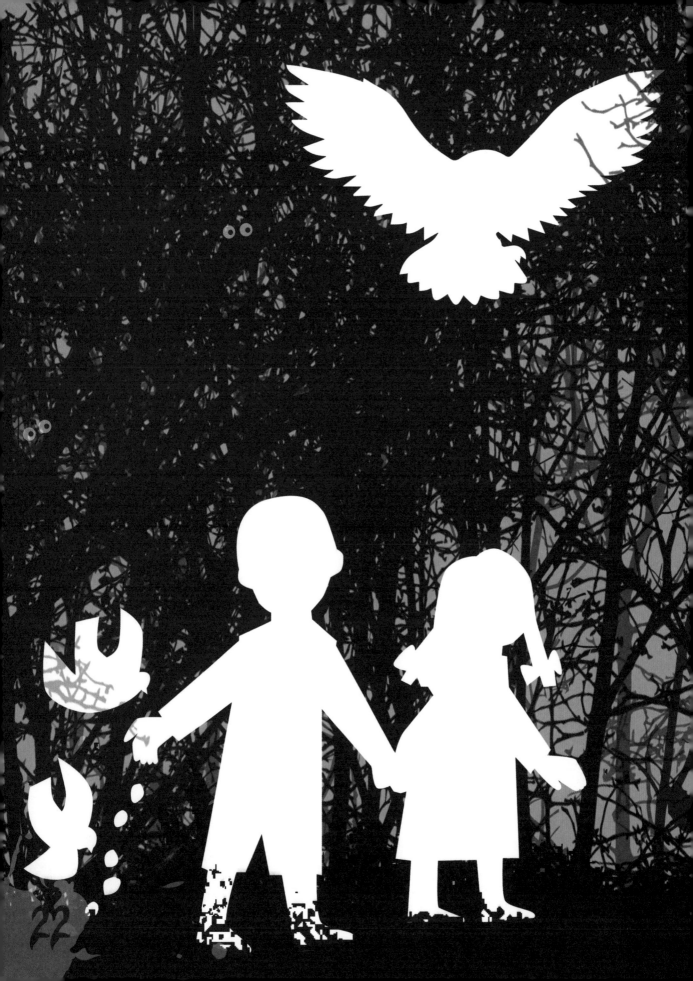

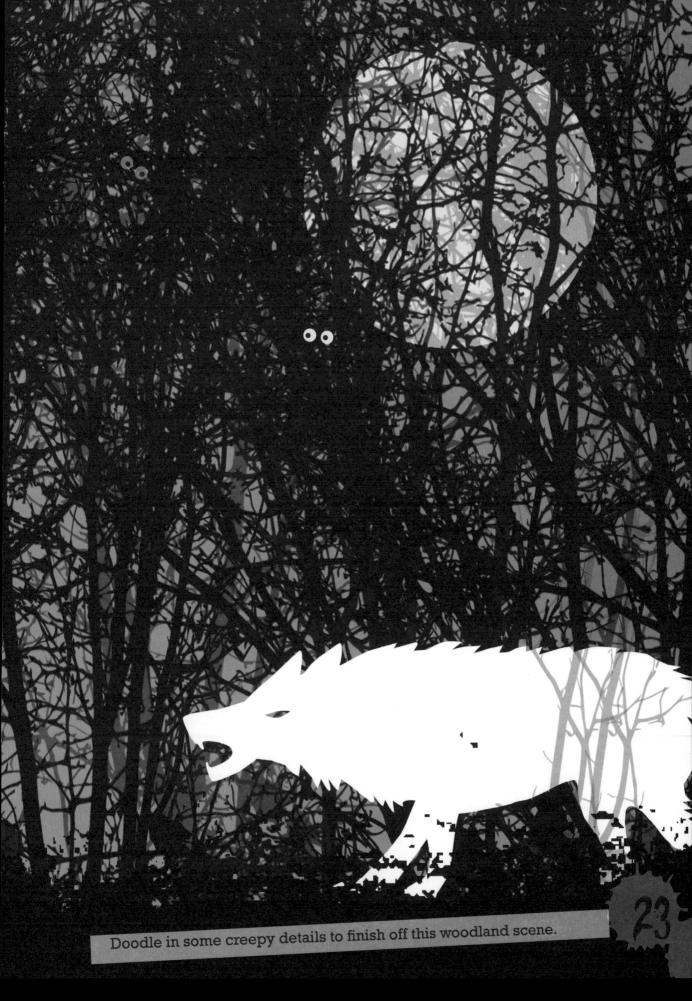

Doodle in some creepy details to finish off this woodland scene.

23

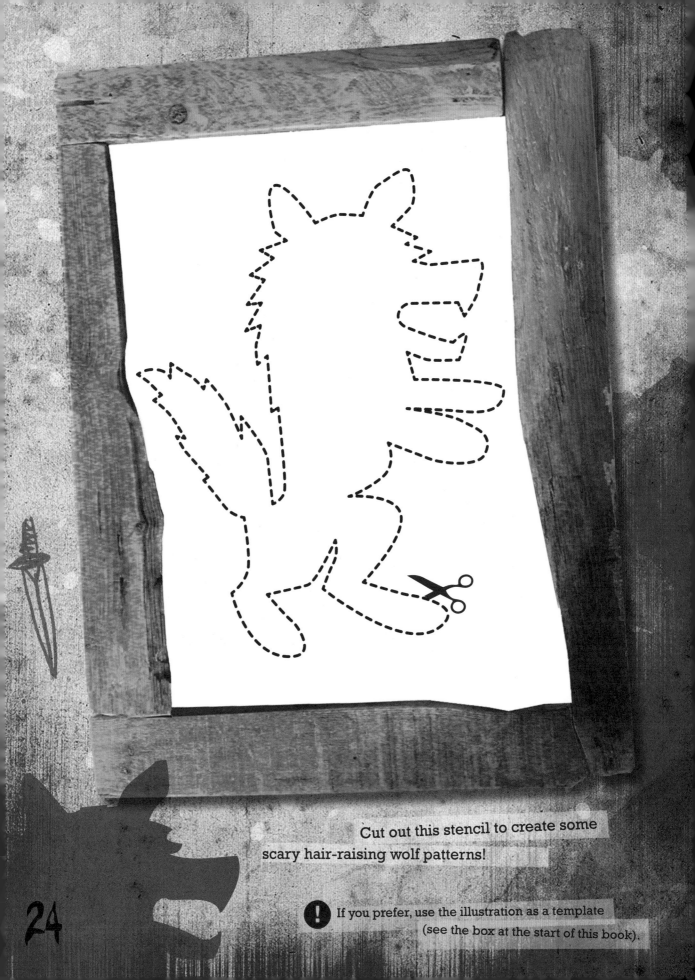

Cut out this stencil to create some scary hair-raising wolf patterns!

If you prefer, use the illustration as a template (see the box at the start of this book).

24

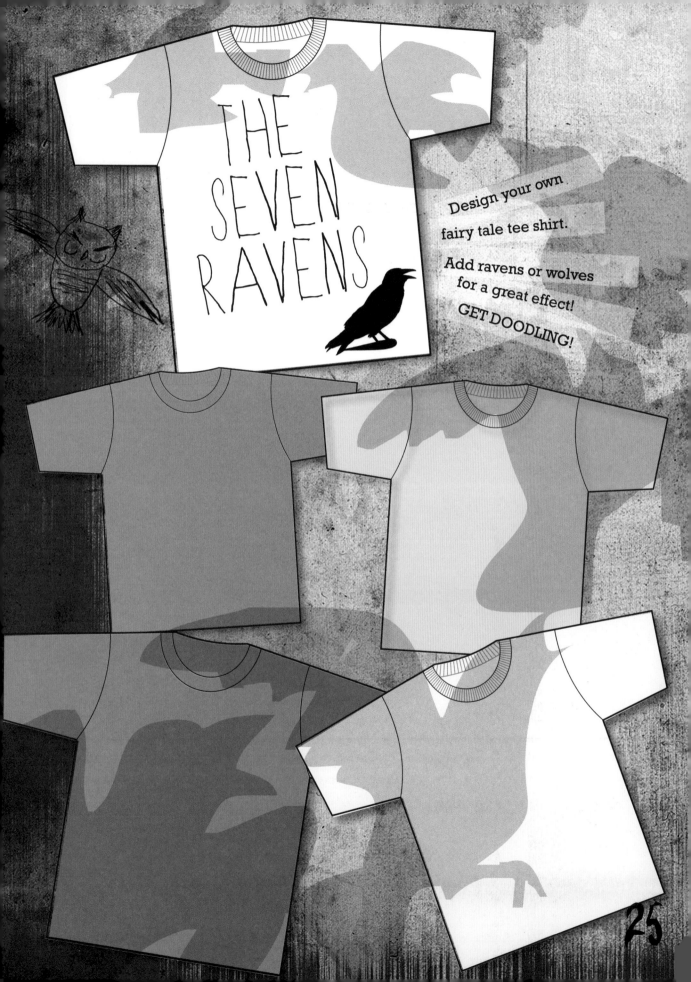

THE SEVEN RAVENS

Design your own fairy tale tee shirt.

Add ravens or wolves for a great effect!

GET DOODLING!

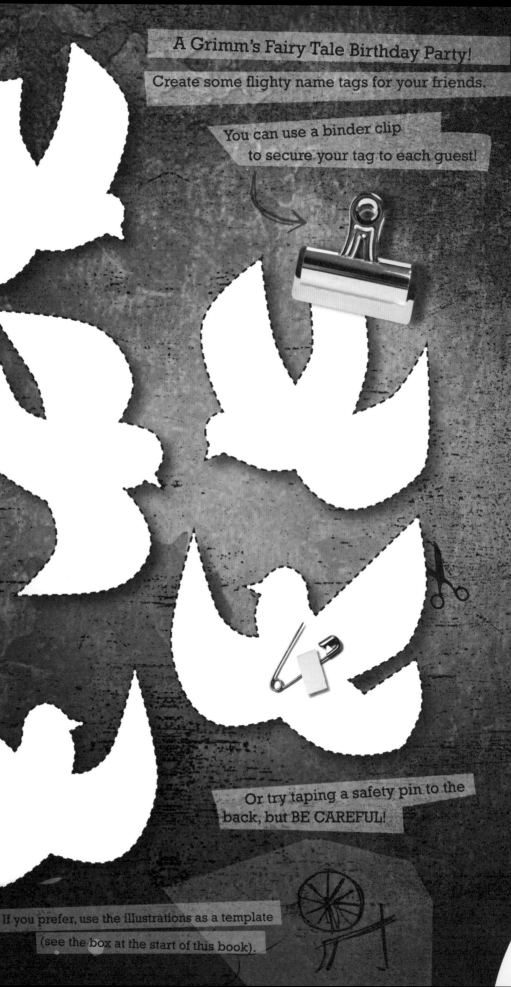

A Grimm's Fairy Tale Birthday Party!

Create some flighty name tags for your friends.

You can use a binder clip
to secure your tag to each guest!

Or try taping a safety pin to the
back, but BE CAREFUL!

26

If you prefer, use the illustrations as a template
(see the box at the start of this book).

HAVE YOUR CAKE AND EAT IT, TOO!

Little Red Riding Hood went into the woods with a cake and juice for her sickly grandmother ...

Draw in the missing details on the grandmother's little house in the woods before it is all eaten up!

A QUIET WORD

e l v e s r b s t v n a
i t o p o m r n n i a k
f b h l e e o s a u m w
i e i i i r t u s m r x
v a a d e s h p a d e v
t w l t w f e k e f h w
k o c a h i r b p c s i
s h n x b e s o c m i f
s p b w o r r a p s f e
s p i n n e r s g i y p
g t r r q i i z f e a k
o s a p r n h w r f p k

fisherman	spinners	feathers
wife	elves	sparrow
tailor	swan	brothers
soldiers	thief	peasant

Draw something wicked here!

29

1

2

3

4

5

6

7

8

9

10

11

12

My Fairy Tale Flick Book

You will need to copy this page four times. Then doodle in your favorite fairy tale character, such as Cinderella or Rapunzel.

Make sure it changes slightly in each frame, to create the movement.

Cut out all the frames and carefully staple them together. **THAT'S IT!**

Now watch your doodle come to life by flicking the pages—

IT'S AMAZING!

BADGE OF HONOR

Doodle in all the details on these badge templates to create your own
Fairy Tale Collection.

You can cut them out and tape
a safety pin to the back or try
using a piece of double-sided
tape for a safe solution.

❗ If you prefer, use the illustrations as a template
(see the box at the start of this book).

TANGLED LINES

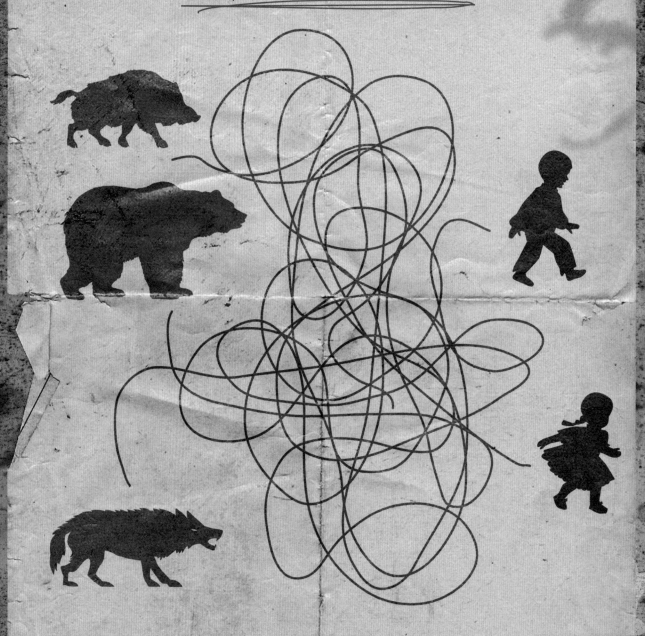

Follow the wiry mass and find out
if Hansel and Gretel escape from
the evil animal clutches that lurk in the dark!

Write your own short story here . . .

A WRITE

GOOD STORY

Don't forget to add
some doodles!

33

HANG FIRE!

ABCDEFGHIJKLMNOPQRSTUVWXYZ

Cross off the dead letters as you go ...

Draw your
hangman over here.

Enter your
secret words here.

_ _ _ _ _ _ _ _ _ _ _ _

ABCDEFG
HIJKLMN
OPQRSTU
VWXYZ

_ _ _ _ _ _ _ _ _ _

Doodle in some dangerous animals that are often found in dark forests and warn Snow White before it's too late!

DANGER

DANGER

35

DOUBLE TAKE!

Can you spot six differences between these two beautiful princesses?

Look very carefully.

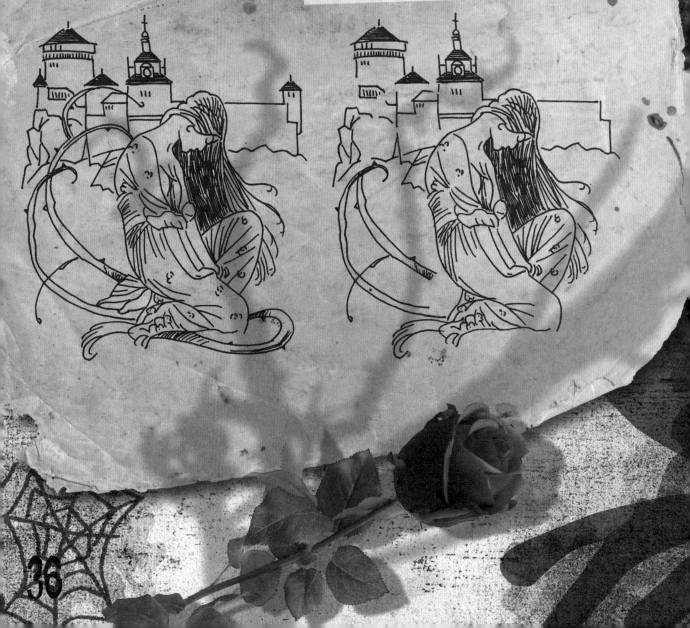

36

CROAK CROAK!

Doodle in some silly details on this slimy frog mask!

Cut it out, tie some elastic through the holes on either side,

and wear it to spook your friends.

NOW LEAP INTO ACTION!

37

If you prefer, use the illustration as a template (see the box at the start of this book).

Write something very secret backward on this bit of old, dirty parchment paper.
Get your friends to guess what you have written.

Now place it in front of a mirror to reveal
your special secret to all your friends—
did they get it?

ABCD
EFGHI
JKLMN
OPQR
STUV
WXYZ

MIRROR MIRROR
ON THE WALL

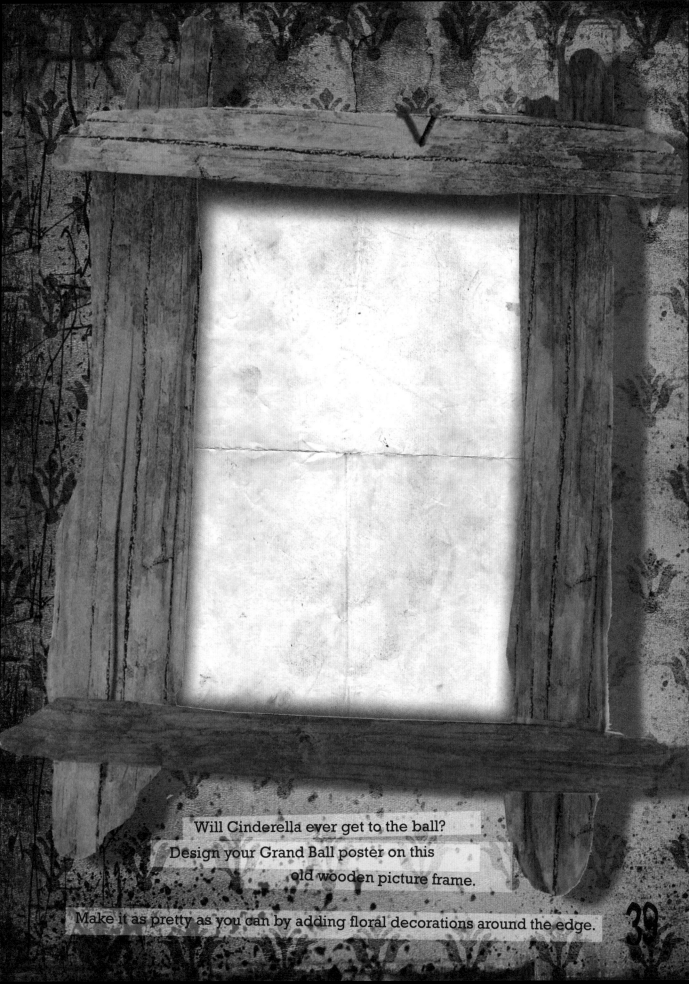

Will Cinderella ever get to the ball?
Design your Grand Ball poster on this
old wooden picture frame.

Make it as pretty as you can by adding floral decorations around the edge.

39

WITCH ONE IS DIFFERENT?

See if you can spot six differences between these two old wicked witches.

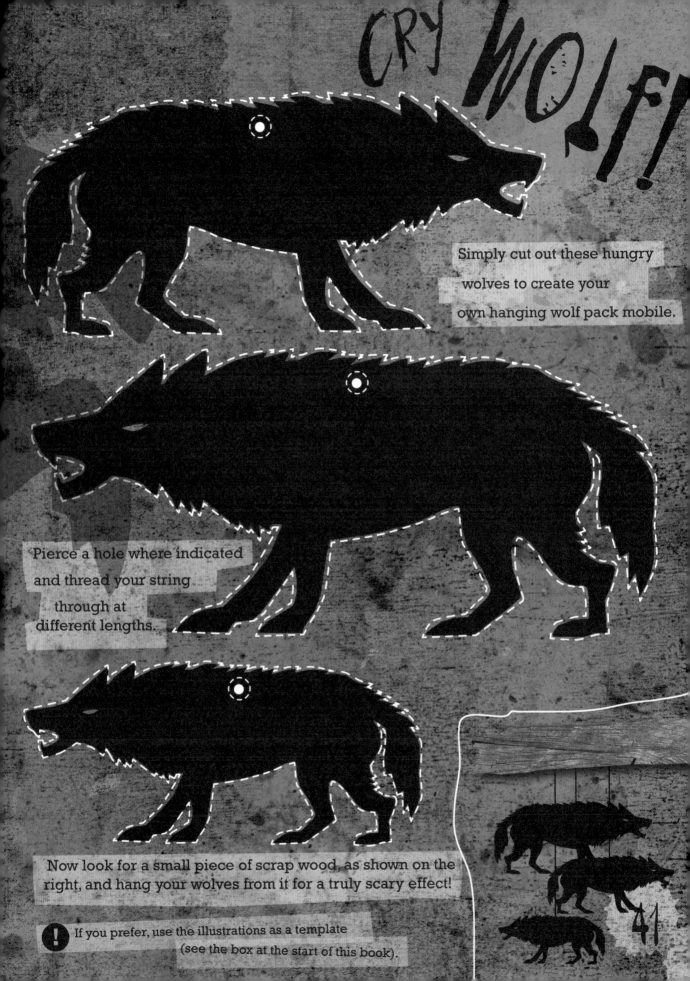

CRY WOLF!

Simply cut out these hungry wolves to create your own hanging wolf pack mobile.

Pierce a hole where indicated and thread your string through at different lengths.

Now look for a small piece of scrap wood, as shown on the right, and hang your wolves from it for a truly scary effect!

! If you prefer, use the illustrations as a template (see the box at the start of this book).

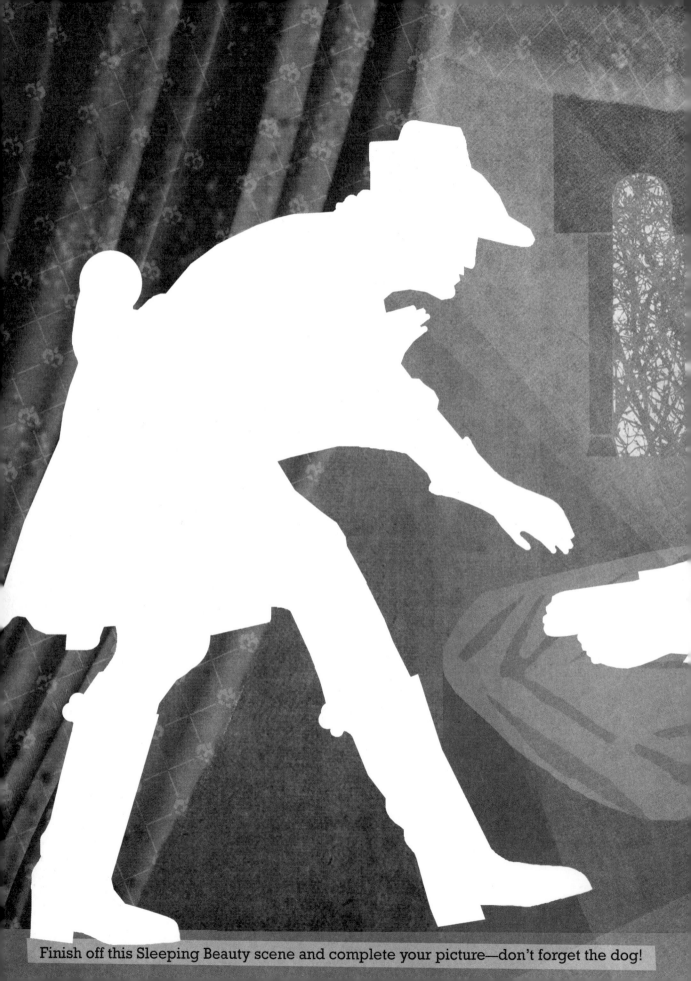

Finish off this Sleeping Beauty scene and complete your picture—don't forget the dog!

43

PRINCE CHARMING?

Cut out this frog stencil and paint your pattern onto anything you fancy.
You could create patterned wrapping paper or maybe make a pretty
birthday card for someone really special, such as Cinderella. BE CREATIVE!

If you prefer, use the illustration as a template (see the box at the start of this book).

44

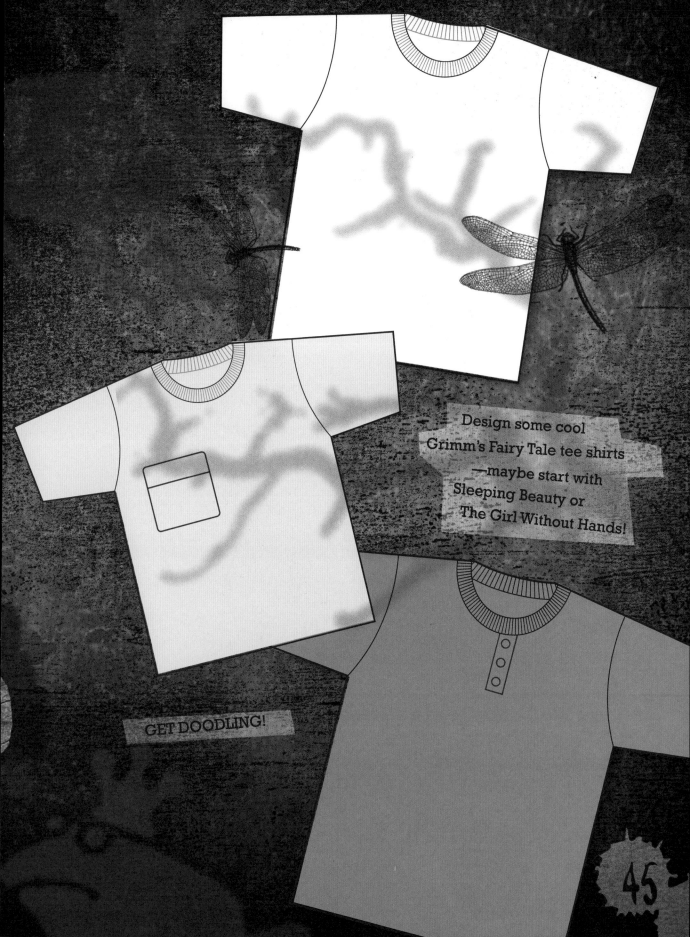

Design some cool
Grimm's Fairy Tale tee shirts
—maybe start with
Sleeping Beauty or
The Girl Without Hands!

GET DOODLING!

45

THE WICKED STEPMOTHER'S POTION...

Lemonade

Apple juice

Cranberry juice

INGREDIENTS

10 oz of cranberry juice
10 oz of apple juice
Top off with lemonade to taste
1 x sliced apple
3 or 4 leaves of fresh mint

Find a large, clean pitcher and pour in the cranberry juice. Now stir in the apple juice and top off with lemonade. You can add as much as you like, but taste it as you go.

Finally, place cut slices of apple and a sprig of mint into the pitcher and give it a good stir.

You now have a secret potion to try out on your friends—if they start giggling then it could be working!

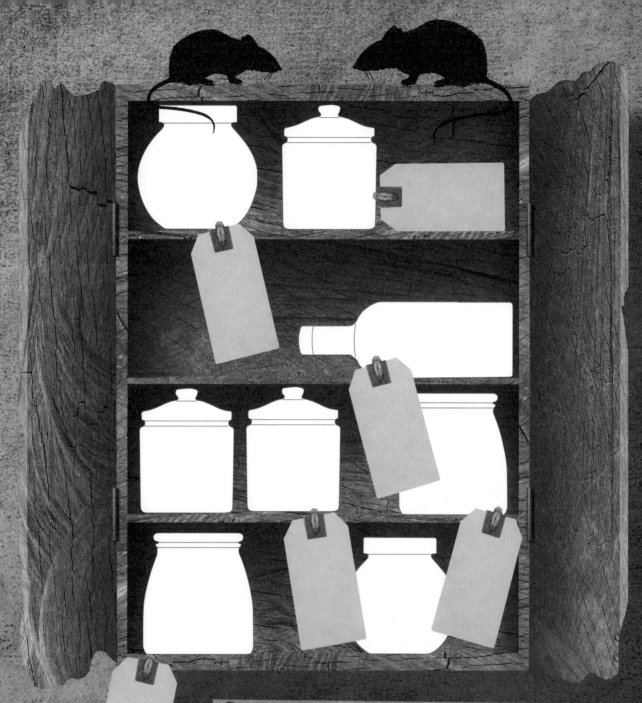

Doodle in some horrid contents in the witch's cupboard, then fill in the labels to complete the task.

TROUBLE CUPBOARD!

47

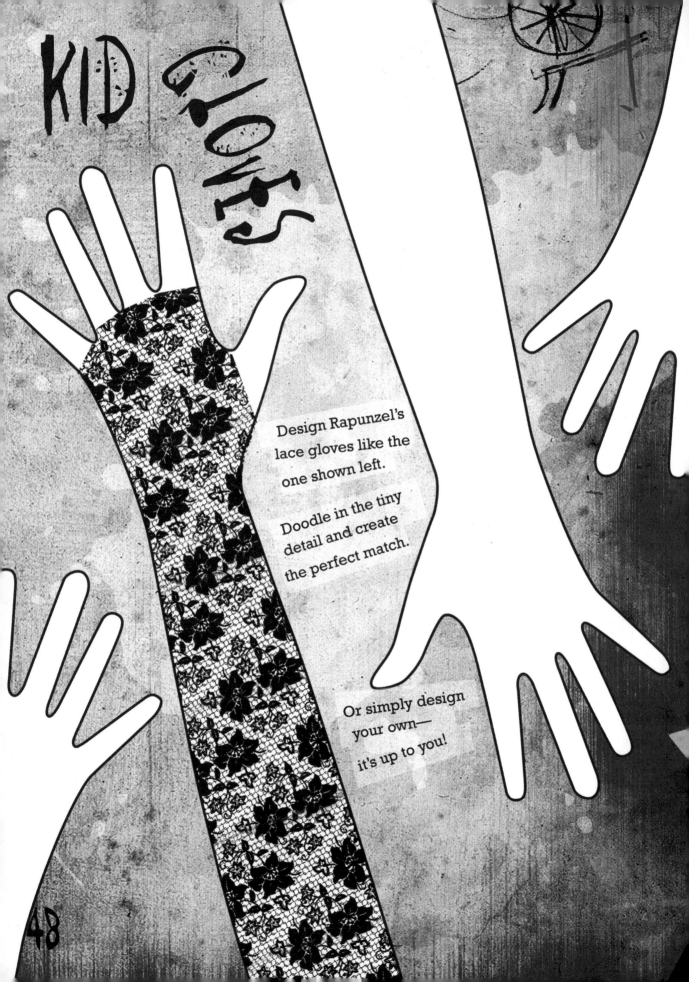

KID GLOVES

Design Rapunzel's lace gloves like the one shown left.

Doodle in the tiny detail and create the perfect match.

Or simply design your own— it's up to you!

48

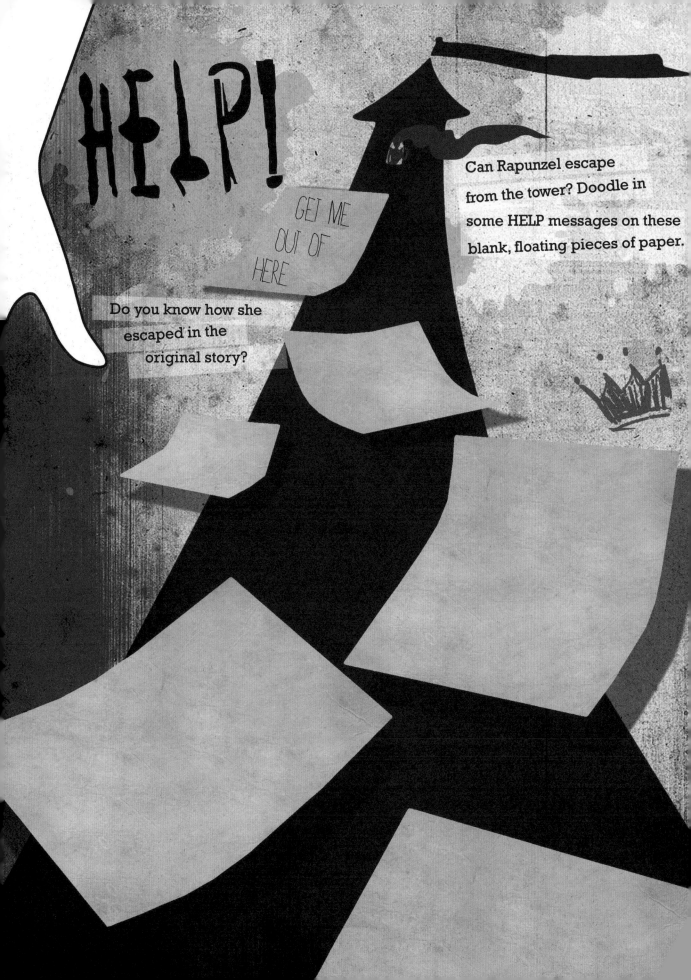

UNDER MY THUMB!

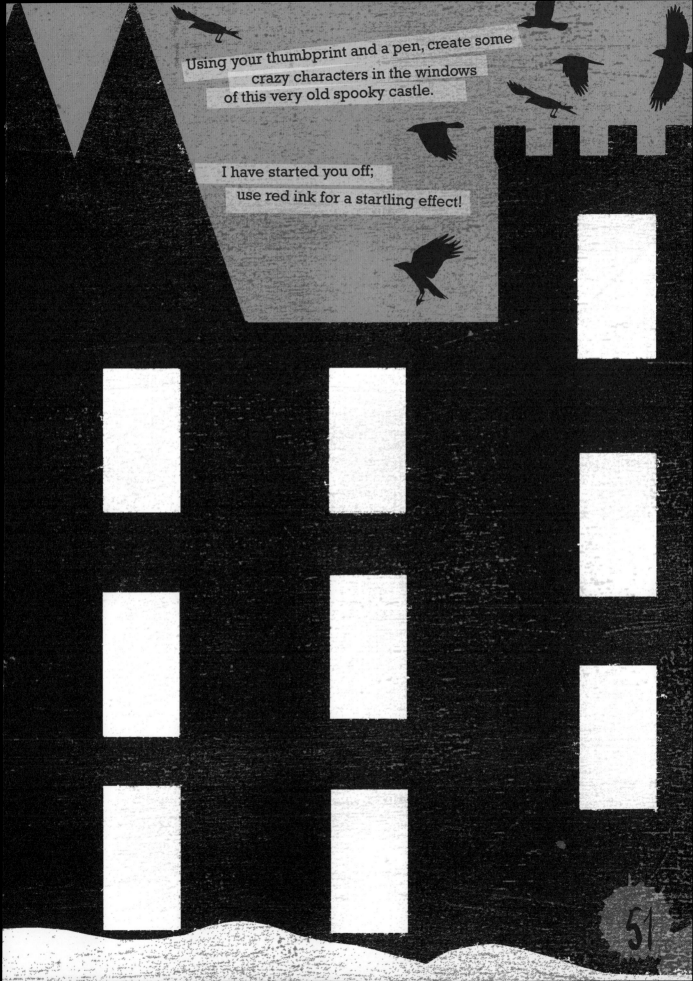

Using your thumbprint and a pen, create some crazy characters in the windows of this very old spooky castle.

I have started you off; use red ink for a startling effect!

51

G W

A R S

Use these samples for inspiration.

Design your own Grimm's old-fashioned alphabet—

remember it would have been drawn with

a quill way back then and been very decorative.

HAPPY DOODLING!

WORD UP!

riddle	goose	gold
devil	gnome	rose
juniper	donkey	knapsack
master	servants	grandson

```
g b r s d a b r z g o k
o r s e o s e r n l n p
o e c r p t g o t a s q
s l d v s i m d p u s u
e d o a i e n s e c v f
k d m n y h a u z v u z
w i l t y c x h j a i d
e r y s k d o n k e y l
p s y v d l o g s w w k
g p o n x m c t g o o o
s y o r q k f x e g r r
p d n o s d n a r g u i
```

Draw something spooky here!

Which path should Snow White take—you decide ...
Can Snow White escape the clutches of the wicked Queen

or can she arrive safely at the old cottage in the woods?

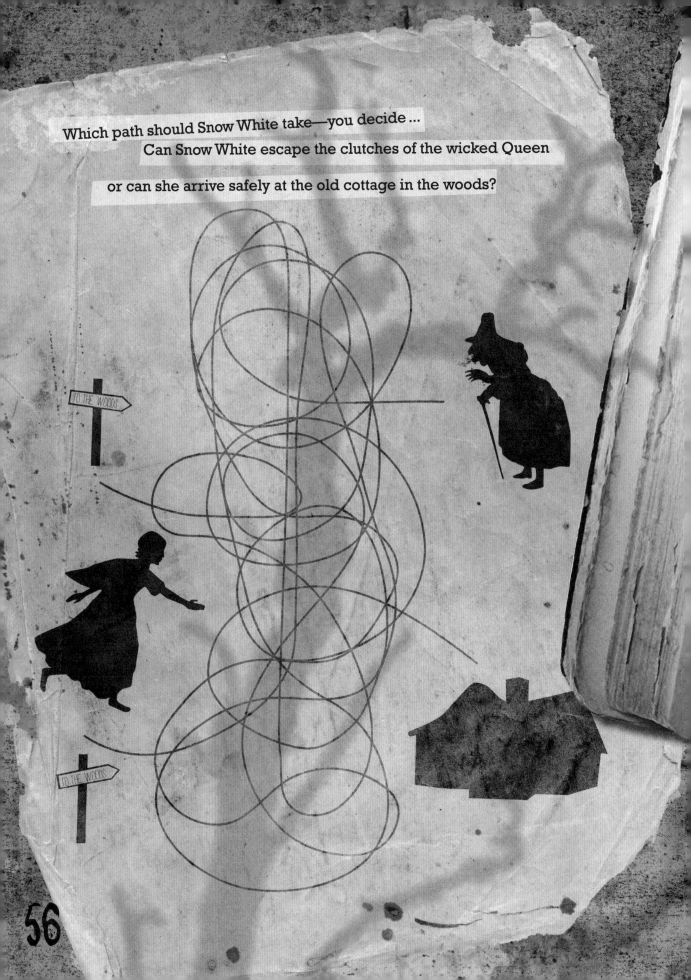

TO THE WOODS

TO THE WOODS

STORYTELLER

HANG ON!

Make up some secret words to use in this simple hangman game. Maybe use characters from your favorite fairy tale stories such as Ferdinand or Cinderella.

Cross off the dead letters.

ABCDEFGHI
JKLMN
OPQRSTU
VWXYZ

Draw your hangman here.

Enter your words here.

ABCDEFG
HIJKLMN
OPQRSTU
VWXYZ

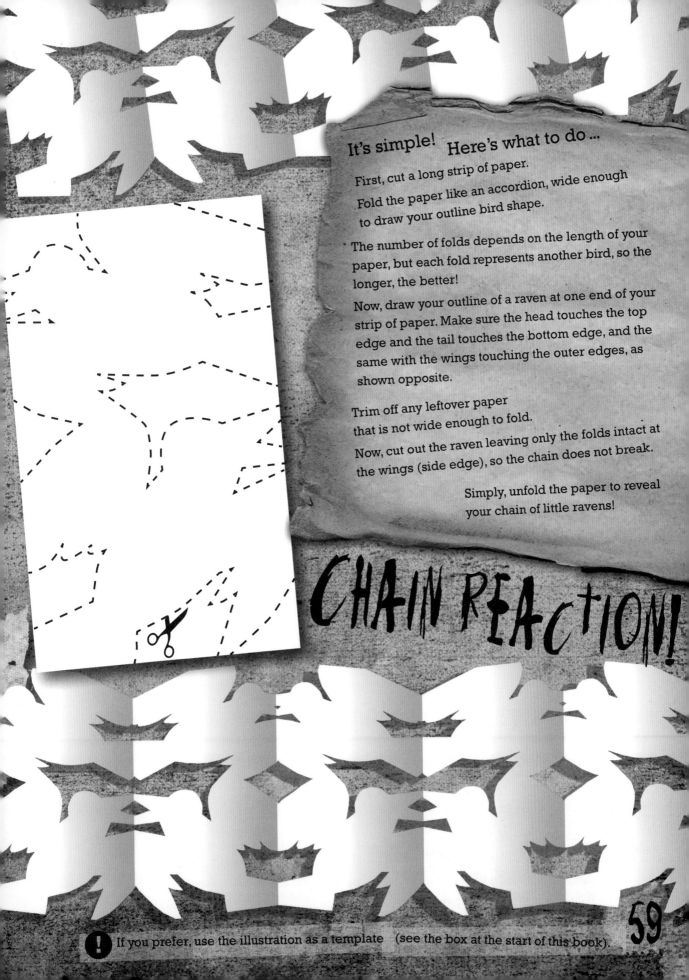

It's simple! Here's what to do ...

First, cut a long strip of paper.

Fold the paper like an accordion, wide enough to draw your outline bird shape.

The number of folds depends on the length of your paper, but each fold represents another bird, so the longer, the better!

Now, draw your outline of a raven at one end of your strip of paper. Make sure the head touches the top edge and the tail touches the bottom edge, and the same with the wings touching the outer edges, as shown opposite.

Trim off any leftover paper that is not wide enough to fold.

Now, cut out the raven leaving only the folds intact at the wings (side edge), so the chain does not break.

Simply, unfold the paper to reveal your chain of little ravens!

CHAIN REACTION!

❗ If you prefer, use the illustration as a template (see the box at the start of this book).

INSIDE FLAP!

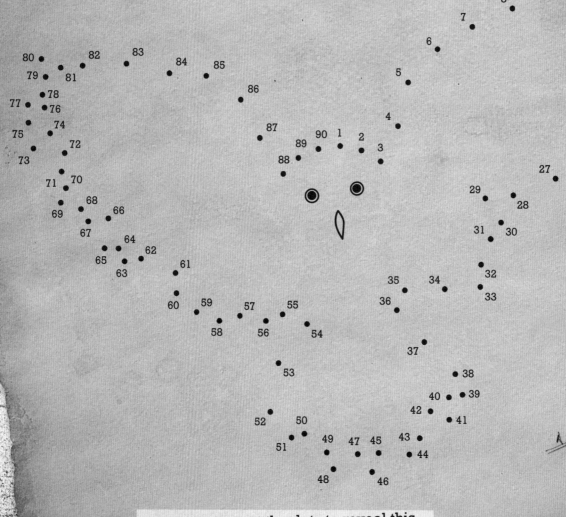

Simply connect the dots to reveal this
unidentified flying object—get it?

60

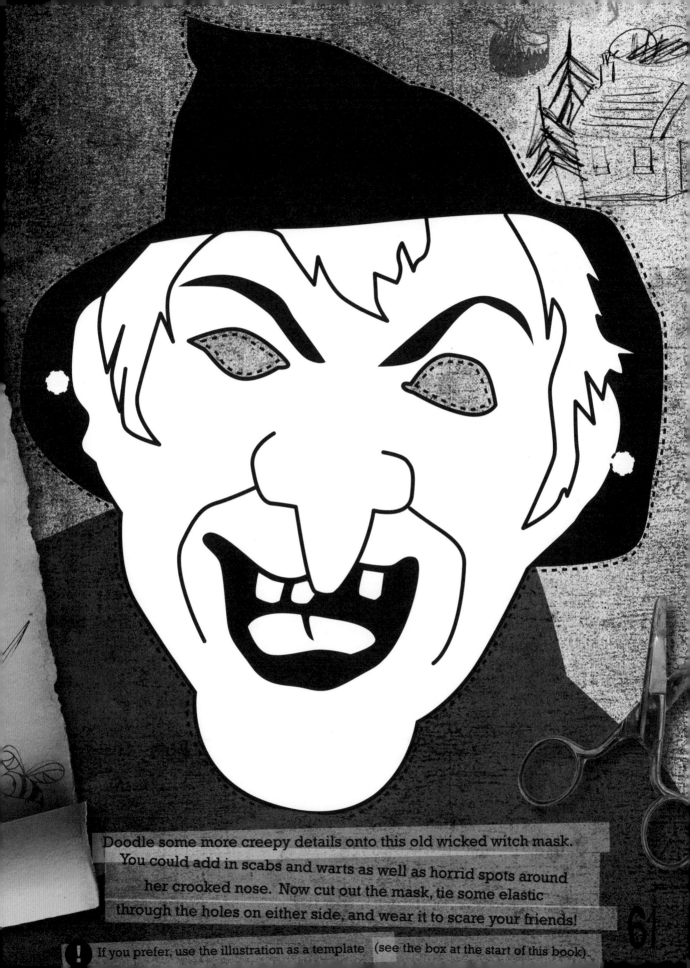

Doodle some more creepy details onto this old wicked witch mask.
You could add in scabs and warts as well as horrid spots around
her crooked nose. Now cut out the mask, tie some elastic
through the holes on either side, and wear it to scare your friends!

! If you prefer, use the illustration as a template (see the box at the start of this book).

Write a backward message to Snow White and warn her of the evil Queen.

"Mirror, mirror on the wall, who is the fairest of them all?"

Place a mirror here

to reveal your

secret message and let Snow White discover the truth!

Draw in your scary backward message on this old bit of useless paper.

ABCD
EFGHI
JKLMN
OPQR
STUVWXYZ

QUEEN

62

TWICE SHY!

Can you spot the six differences between the two Little Red Riding Hoods?

Look carefully into the detail then circle your findings with a pencil.

KING OF THE CASTLE

Cut out these cool castles and create your very own hanging mobile.

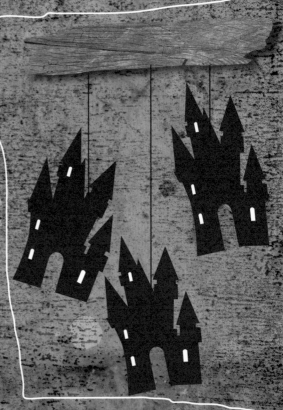

Look for a small fallen branch or a scrap piece of wood

and hang these at different lengths for a great effect!

You could hang ribbons out of the top windows and create a scene from Rapunzel's classic fairy tale story.

BE CREATIVE!

65

If you prefer, use the illustration as a template (see the box at the start of this book).

66

GOING BATTY!

Carefully cut out this stencil and create your own flappy batty night scene!

⚠ If you prefer, use the illustration as a template (see the box at the start of this book).

CREATURES GREAT AND SMALL!

The animals on these pillars in the palace gardens have magically come to life! Use your thumbprint, then doodle them in.

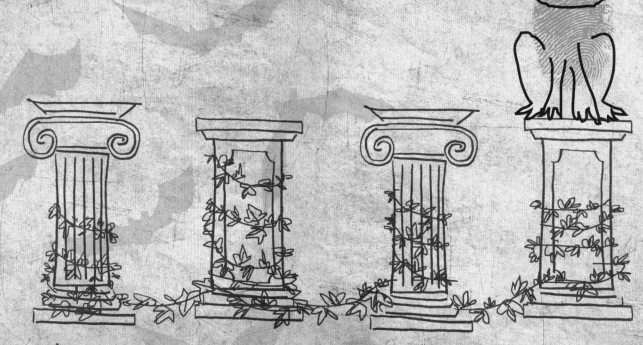

Choose from your favorite fairy stories, such as a frog, raven, swan, or maybe a fox?

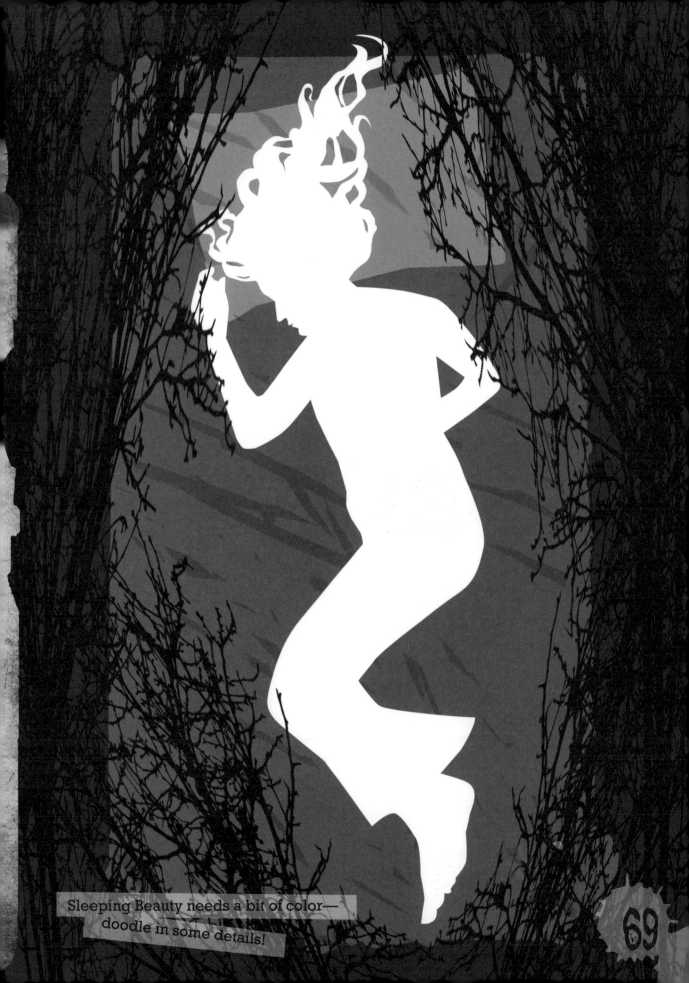

Sleeping Beauty needs a bit of color—doodle in some details!

69

You have been invited to the Grand Ball by the King—
now design your own fancy invitations on these blank cards.

Nice mug shot!

Doodle in some designs
on these dirty old mugs
inside the old grandmother's cottage.

Who's having hot chocolate?

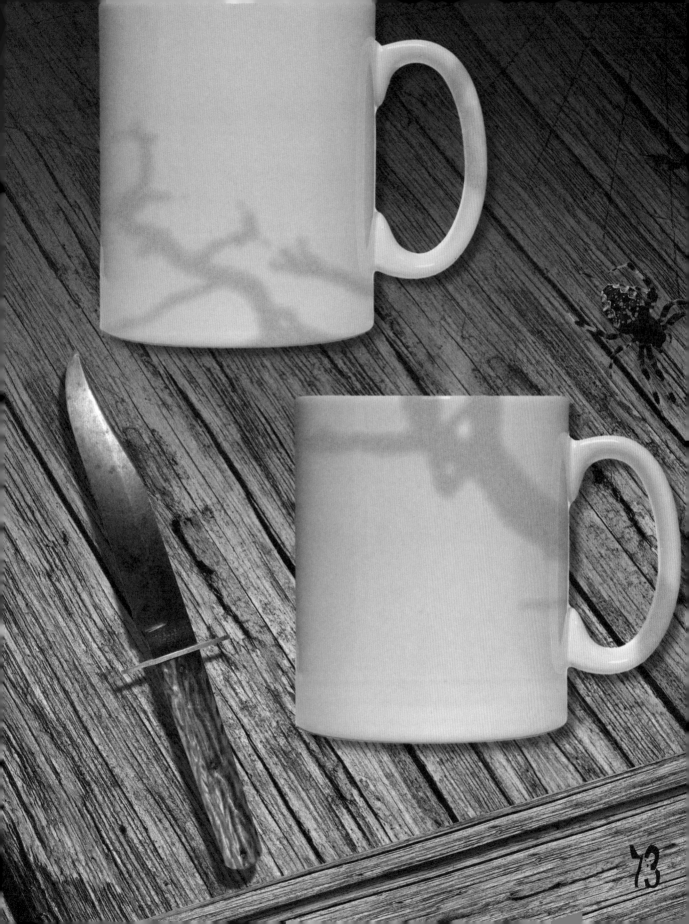

73

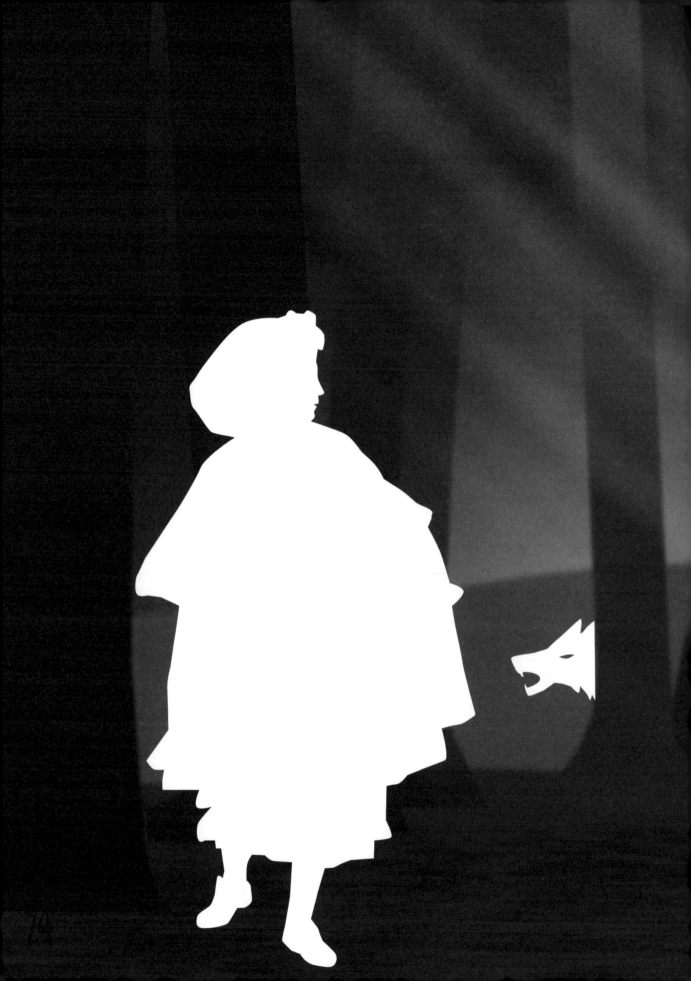

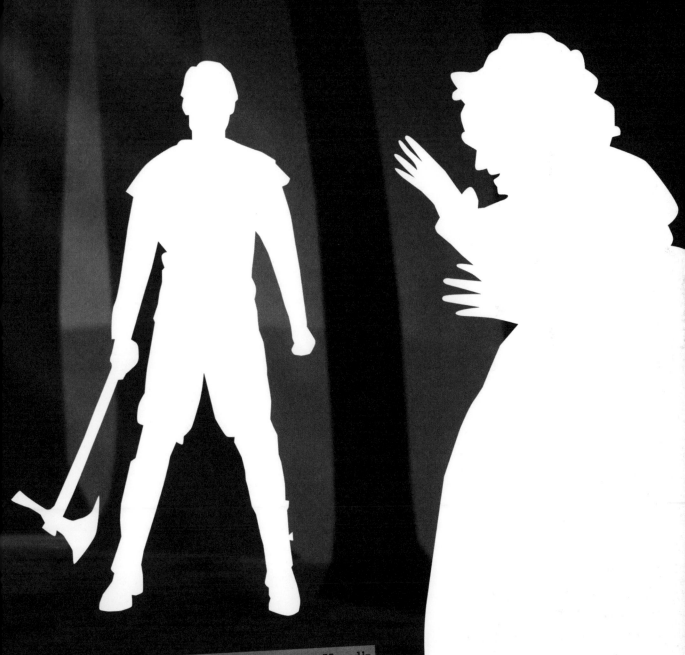

Doodle in the details in Little Red Riding Hood's unusual gathering—don't forget the wolf!

WORD UP!

```
m w c n s n m s i g p n
c o r r e v i u r d r i
u g u v o s v a z z i r
x z a n t w v m v u n q
v e d e t e s x f k c q
h e r p a a e n o b e w
u s t u x r i d d t s i
e l t s a c e n z s s t
d e a t h t n b g e t c
e h f m i a w d b r s h
c z b o e j i w b o l d
j s b p g s n m i f r p
```

castle	death	princess
sisters	crows	grave
bone	witch	forest
robber	mountain	Heaven

Draw something fairy tale-ish here …

If Cinderella is going to the ball, she will need her nails beautifully decorated—design and paint her nails how you imagine they might look.

Which path should the mouse follow to change into the footman?

Will the pumpkin change into the carriage?
Carefully trace the tangled lines and discover their fate!

80

BY INVITATION ONLY

You have been invited to the grand ball in the castle!
Create your perfect invitation wish list.

HANG UPS!

ABCDEFGHI
JKLMN
OPQRSTU
VWXYZ

Draw your hangman here.

Cross off the dead
letters as you go ...

— — — — — — — — — —

Enter your secret words here.

ABCDEFG
HIJKLMN
OPQRSTU
VWXYZ



— — — — — — —

Using the example letters below, design
your embroidered warning message to
Cinderella as it is getting close to midnight!

WATCH OUT!

ABCD
EFGH
IJKL
MNO
PQRS
TUV
WXYZ

PAWS
FOR A MOMENT

Who met Mr. Fox in the woods?
Connect the dots to reveal the truth.

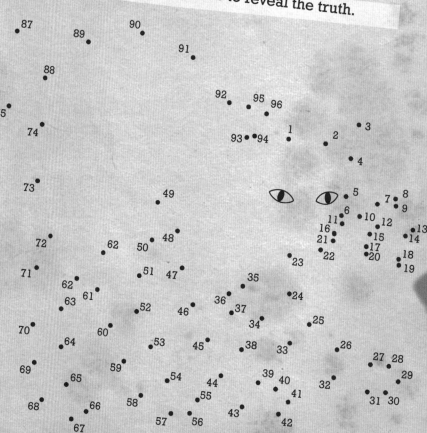

84

WANTED
DEAD OR ALIVE

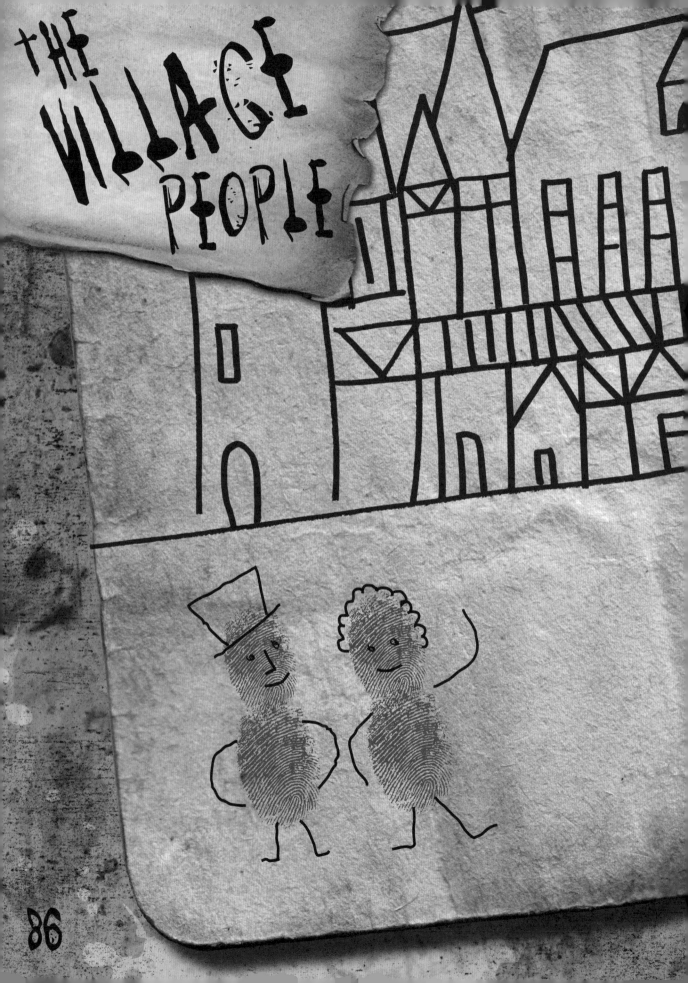

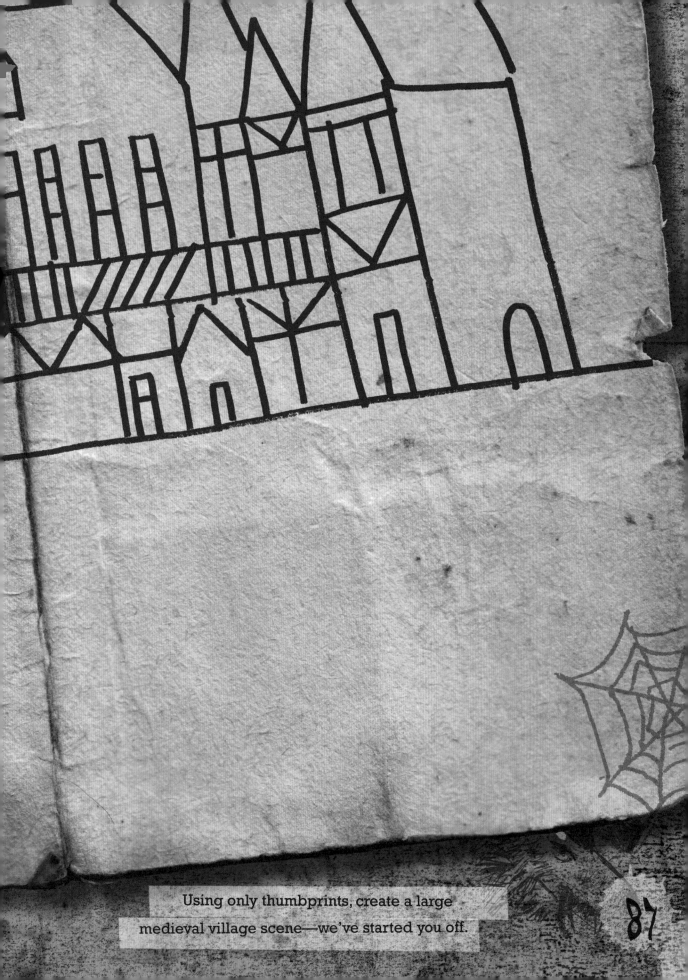

Using only thumbprints, create a large
medieval village scene—we've started you off.

87

BOOKWORM!

Can you spot the six diffences between these two Grimm brothers?

Doodle something impish and interesting here.

Cut out this stencil and create your own jewel in the crown!

CROWN JEWELS

If you prefer, use the illustration as a template
(see the box at the start of the book).

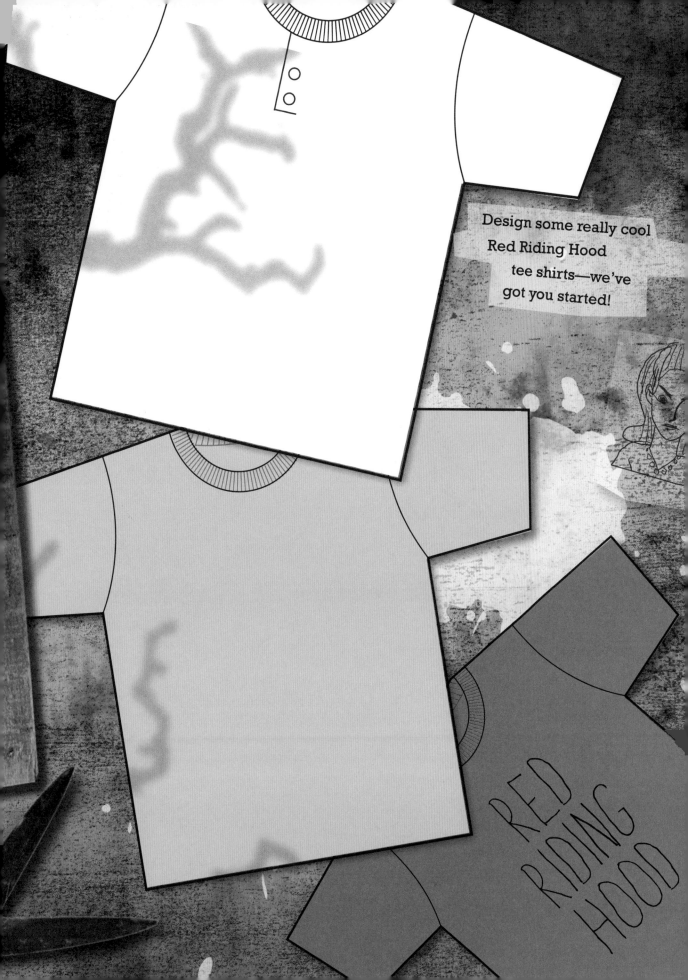

Design some really cool
Red Riding Hood
tee shirts—we've
got you started!

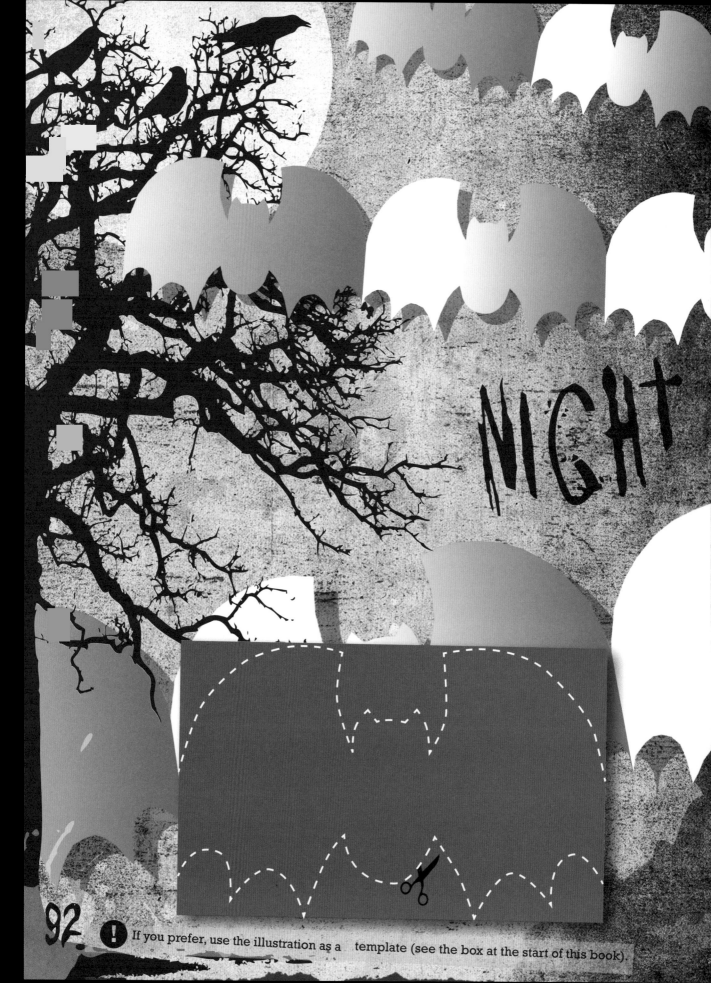

NIGHT

92

FLIGHT

It's simple! Here's what to do ...

First, cut a long strip of paper.

Fold the paper like an accordion, wide enough to draw your bat outline.

The number of folds depends on the length of your paper, but each fold represents another bat, so the longer, the better! Trim off any leftover paper that is not wide enough to fold.

Now, draw your outline of a bat at one end of your strip of paper. Make sure the top of the wing touches the top edge, and the bottom of the wing touches the bottom edge, and the sides of the wings touch the outer edges, as shown on the template.

Cut out the bat leaving only the folds intact at the side edges of the wings so the chain does not break.

Unfold your paper to reveal your chain of batty bats!

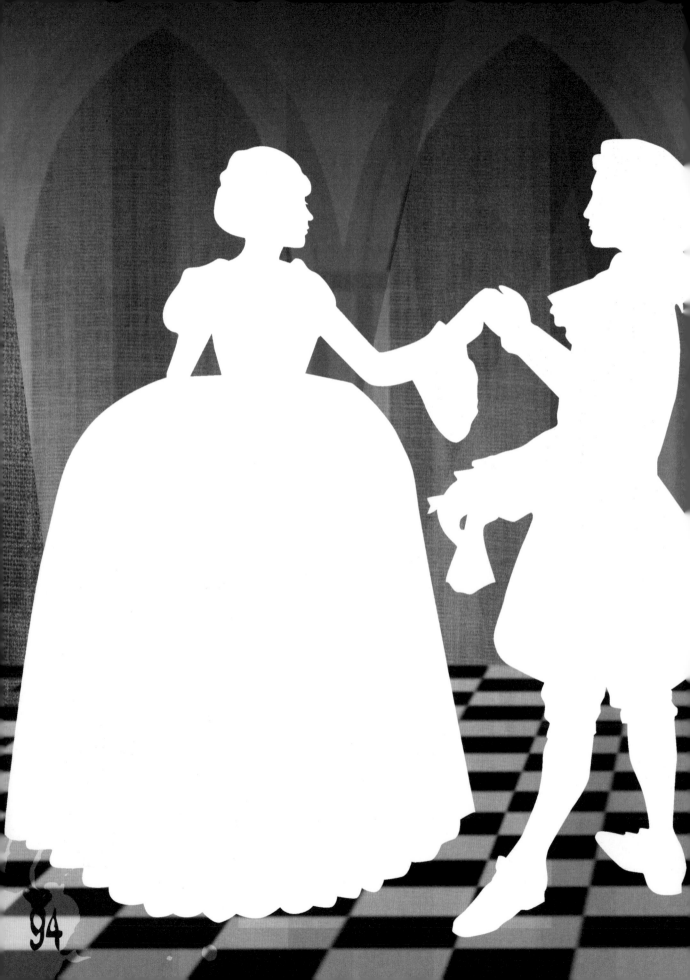

94

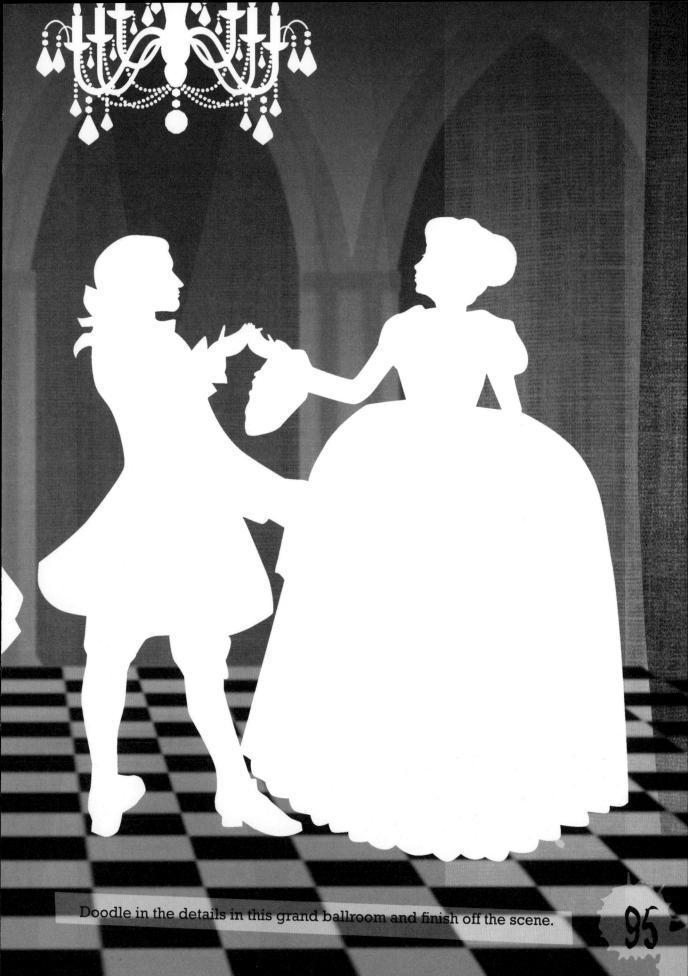

Doodle in the details in this grand ballroom and finish off the scene.

95

Chisel out a final message of sympathy from the evil, dead wolf!

GRAVE CONCERNS

HERE LIES...

Write down your own life story here ...

FRIEND OR FOE

Doodle in more of your favorite characters, and some of your worst, of course!

98

99

Imagine your friends as fairy tale characters—doodle them in and show how you think they might have looked in days gone by.

BE CREATIVE!

101

KIND WORDS!

coffin	miller	shoes
Gretel	mirror	spindle
fairies	musician	spinster
folklore	scissors	tower

```
c  u  t  e  o  j  s  h  u  f  d  c
s  d  s  k  q  e  s  r  h  n  o  p
p  z  r  t  o  w  e  r  f  f  u  x
i  y  o  h  y  t  w  f  f  x  u  p
n  i  s  r  s  f  a  i  r  i  e  s
d  a  s  n  d  t  n  q  n  l  q  v
l  t  i  r  r  d  s  c  x  a  r  q
e  p  c  c  e  r  o  l  k  l  o  f
s  x  s  a  i  l  k  u  y  v  r  n
x  d  m  v  j  s  l  x  z  d  r  f
l  e  t  e  r  g  u  i  j  a  i  f
s  a  a  o  z  s  o  m  m  h  m  b
```

Draw something interesting here.

Don't forget your doodles!

Can the prince find Snow White, or does the dwarf
win her over? Follow the tangled lines and see ...

105

HANG AROUND!

DRAW YOUR HANGMAN HERE

ENTER YOUR WORD HERE

can be up to 11 letters

_ _ _ _ _ _ _ _ _ _ _

ABCDEFGHIJKLMN
OPQRSTU
VWXYZ

CROSS OFF THE
DEAD LETTERS

_ _ _ _ _ _ _ _ _ _ _

ABCDEF GHI
JKLMN
OPQRSTUVWXYZ

BADGERED!

Doodle in all the fine details
on these badges just for fun.

Then add a safety pin
on the back of each with sticky
tape to complete the task.

Or try taping a safety pin to the
back, but BE CAREFUL!

If you prefer, use the illustrations as
a template (see the box at the start of this book).

LITTLE PEOPLE!

Connect the dots to reveal the little character singing and dancing around the fire. Can you guess his name?

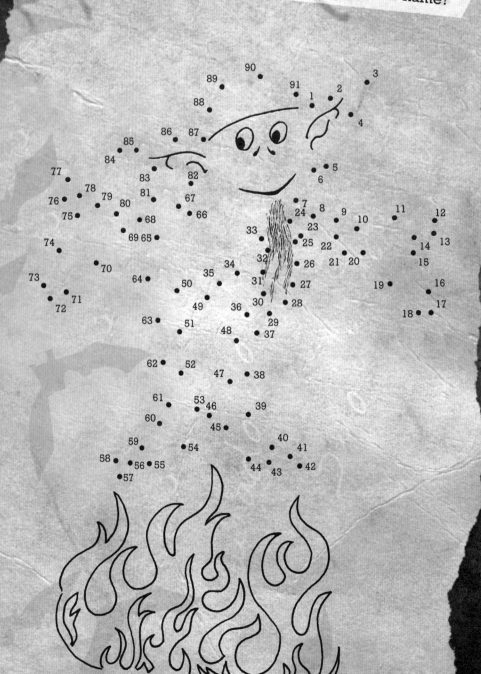

Cinderella is looking to meet a
handsome Prince to take her to the ball.

Finish off this poster describing her
perfect dancing partner—BE CREATIVE!

NICE LEGS!

Use this stencil for your eight-legged scary paper chain.

It's simple! Here's what to do ...

First, cut a long strip of paper.

Fold the paper like an accordion, wide enough to draw your spider outline.

The number of folds depends on the length of your paper, but each fold represents another spider, so the longer, the better! Trim off any leftover paper that is not wide enough to fold.

Now, draw your outline of a spider at one end of your strip of paper. Make sure the legs touch the outer edges, as shown on the template.

Cut out the spider, leaving only the folds intact at the side edges of the legs so the chain does not break.

Unfold to reveal your chain of scary spiders!

! If you prefer, use the illustrations as a template (see the box at the start of the book).

1

2

3

4

5

6

7

8

9

10

11

12

Another Fairy Tale Flick Book

You will need to copy this page four times. Then doodle in your favorite fairy tale character, such as the old grandmother or wolf, or how about a prince or princess?

Make sure it changes slightly in each frame, to create the movement.

Cut out all the frames and carefully staple them together.

THAT'S IT!

Now watch your doodle come to life by flicking the pages— IT'S AMAZING!

❗ If you prefer, use the illustrations as a template (see the box at the start of this book).

111

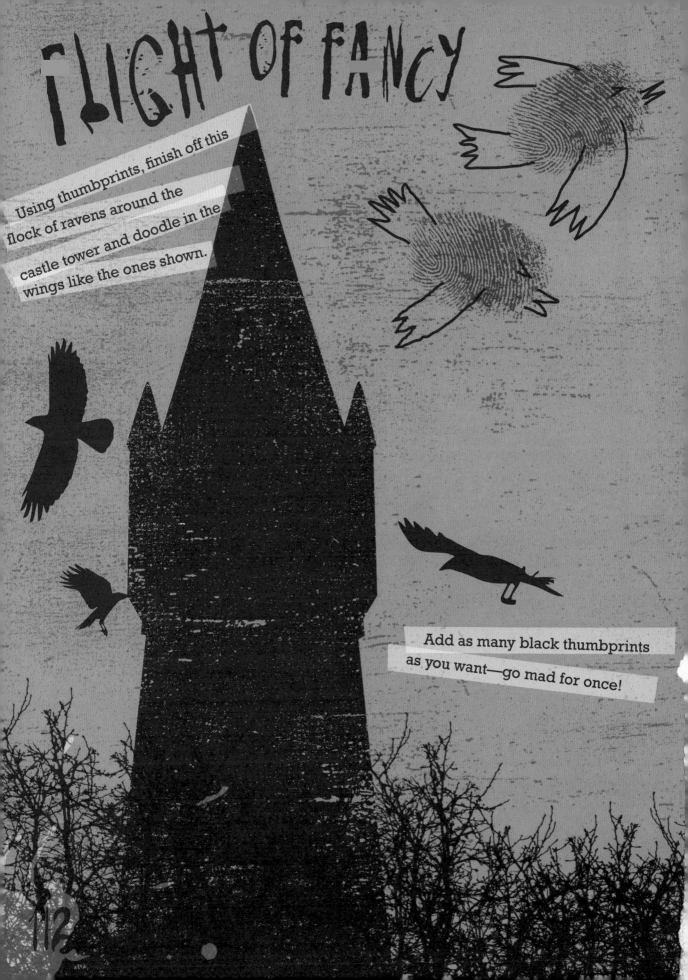

FLIGHT OF FANCY

Using thumbprints, finish off this flock of ravens around the castle tower and doodle in the wings like the ones shown.

Add as many black thumbprints as you want—go mad for once!

GOING MOBILE...

Write down your top ten favorite
Grimm's fairy tale characters here ...

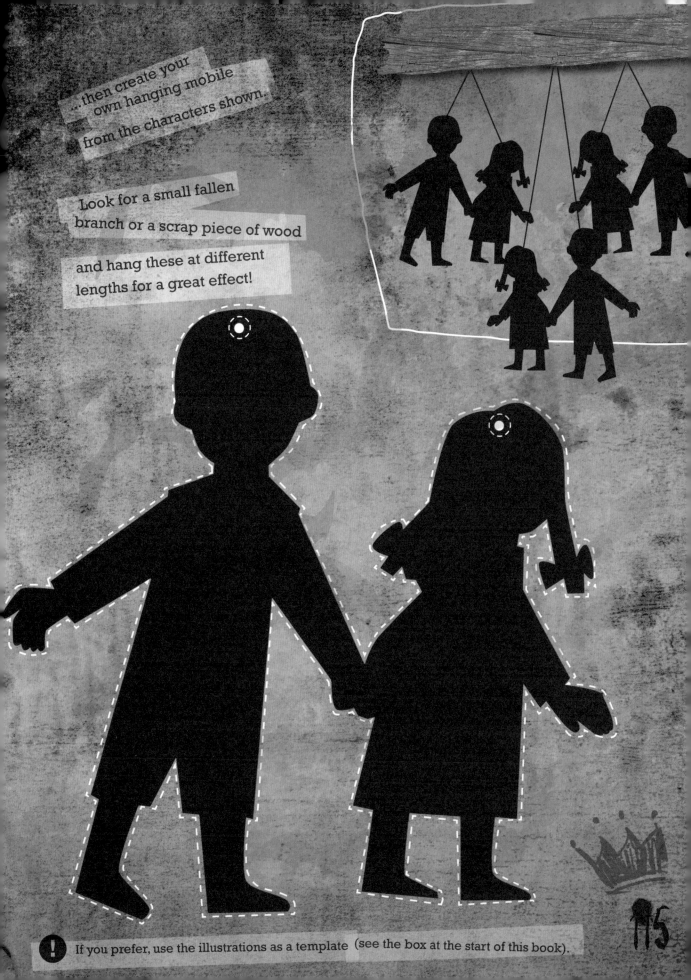

...then create your own hanging mobile from the characters shown.

Look for a small fallen branch or a scrap piece of wood

and hang these at different lengths for a great effect!

! If you prefer, use the illustrations as a template (see the box at the start of this book).

115

A TALL STORY!

Write your own short story here. Be as creative as you can and finish off with some funny doodles.

FEET FIRST!

Doodle in and decorate. Cinderella's glass slipper—they can be whacky or just very pretty; it's your choice!

We've started you off . . .

MAN OR MOUSE?

Doodle in the details on this silly mouse image and create your very own fun play mask.

Cut it out, tie some elastic through the holes, and wear it to scare your friends! Girls WATCH OUT! There's a mouse about!

! If you prefer, use the illustration as a template (see the box at the start of this book).

HOMECOMING...

Can you spot the the six differences between these two cottages nestled deep in the woods?

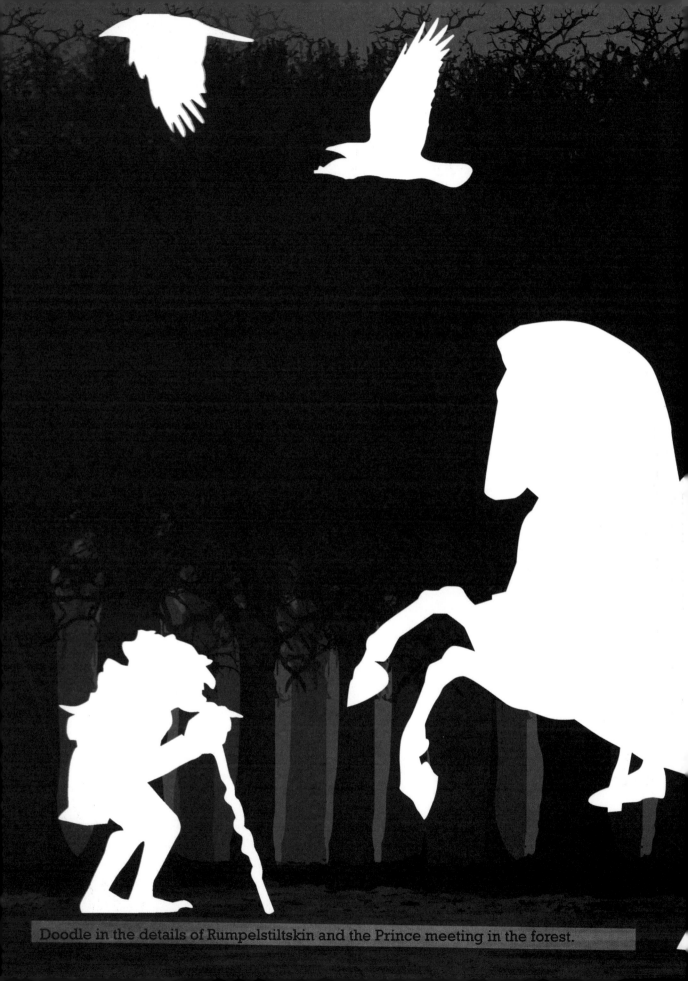

Doodle in the details of Rumpelstiltskin and the Prince meeting in the forest.

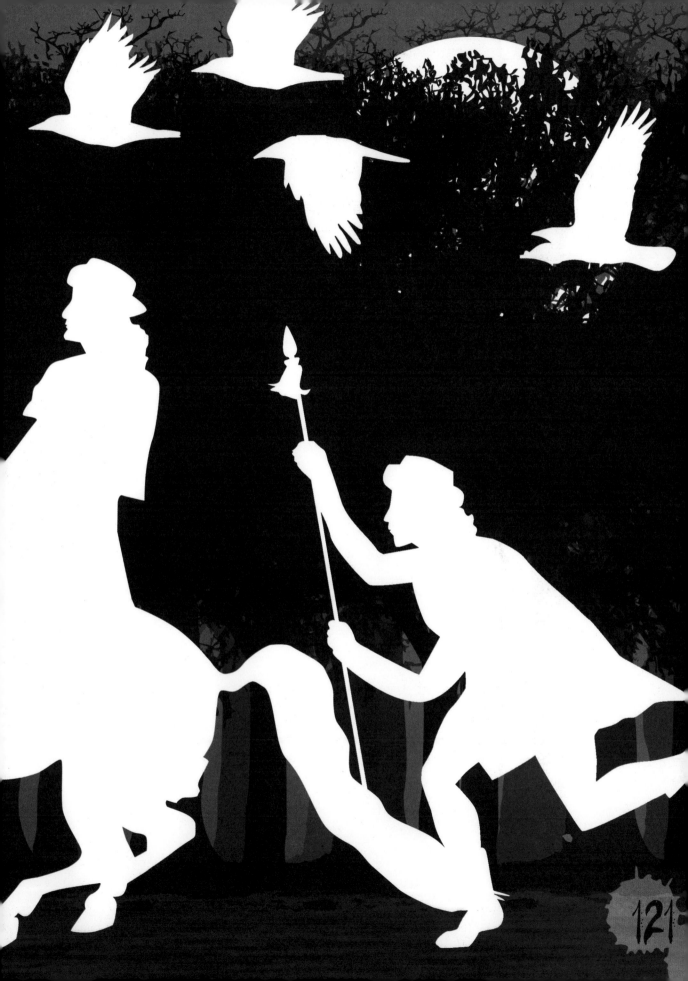

121

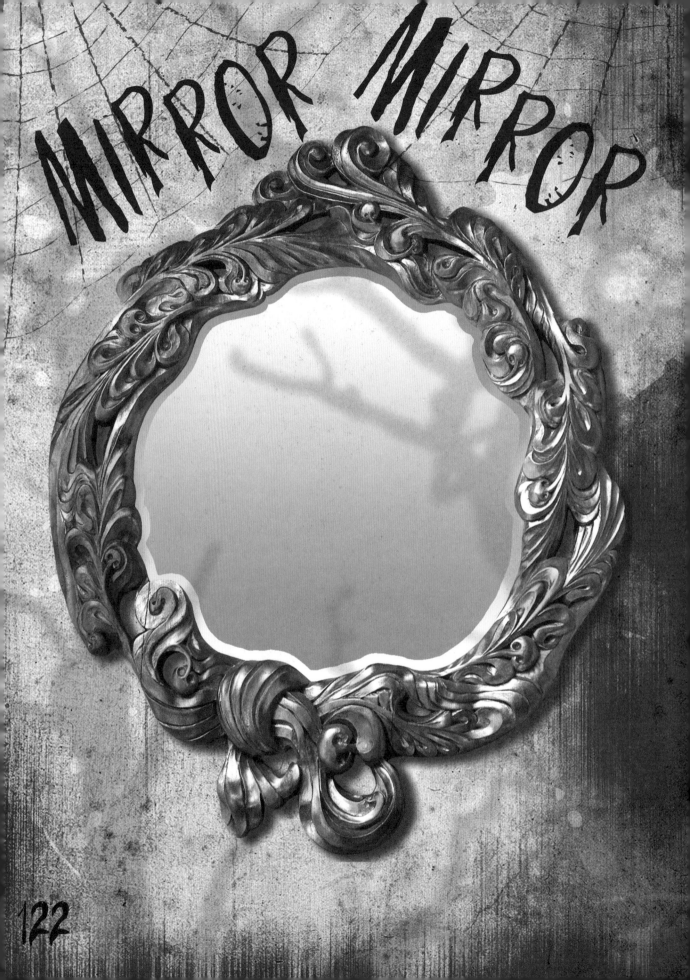

MIRROR MIRROR

ON THE WALL

Doodle in what you think the wicked Queen might see in each of the mirrors—make them as pretty as you can by adding in some painted lips, and of course a beauty spot!

AMAZING GRACE

Help Cinderella find her glass slipper before midnight in this beautifully manicured garden maze.

Try timing yourself, then test your friends to see who is quickest!

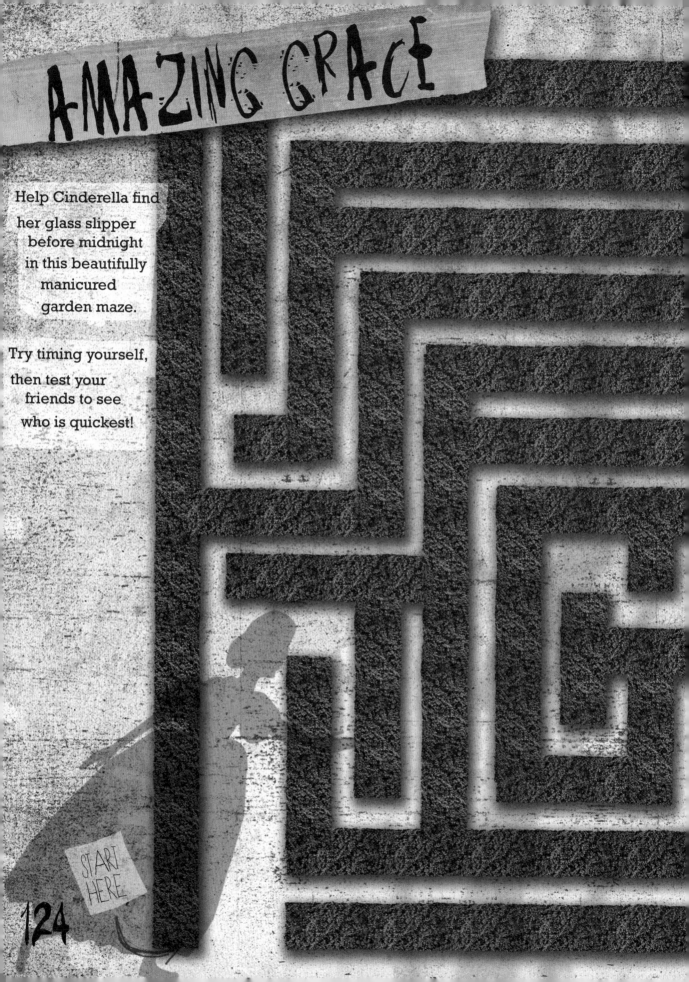

START HERE

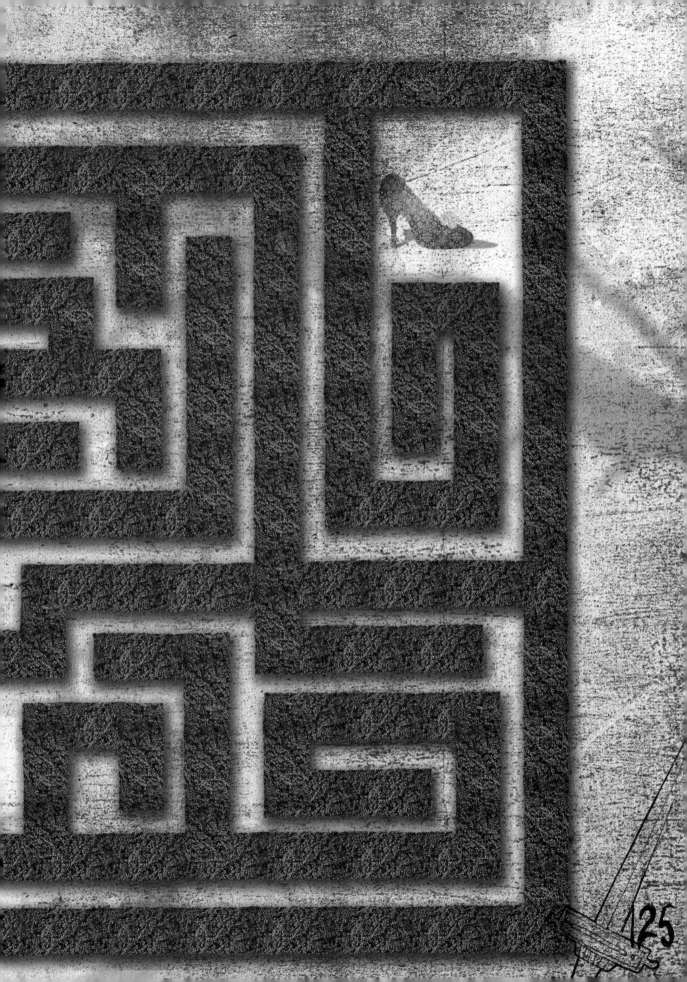

25

ANSWERS

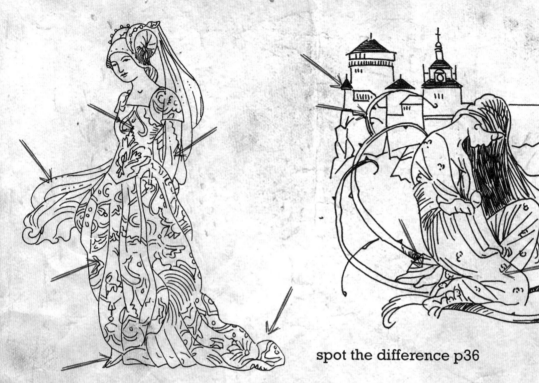

spot the difference p18

spot the difference p36

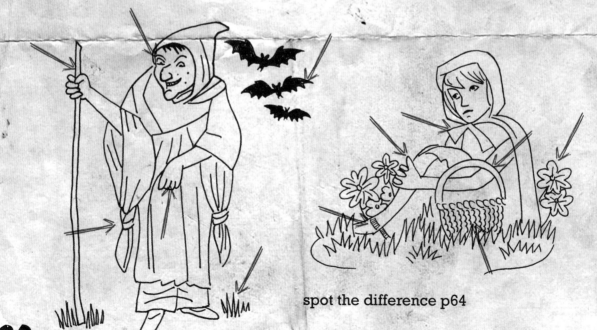

spot the difference p40

spot the difference p64

spot the difference p88

spot the difference p119

word search p8

word search p28

127

word search p54

```
g b r s d a b r z c o k
o r s e o s e r a l r p
o e c r p t g o t a s q
s l d v s i m d p u s u
e d o c i e n s e c v f
k d m n y h a u z v u z
w i l f y c x h j a i d
e r y s k d o n k e y l
p z y v d l o g s w w k
g p o n x m c t g o o o
s y o r q k f x e g r r
p d n o s d n a r g u i
```

word search p76

```
m w c n s n m s i g p n
c o r r e v i u r d r i
u g u v o s v a z z i r
x z a n t w m v u n q
v e d e t e s x f k c q
h e r p a d e n c b e w
u s t u x r i d d t s
e l t s a c e n z s s t
d c a t h t n n g e t c
e h f m i a w d b r s h
c z b o e j i w b o l d
j s b p g s n m i l r p
```

word search p102

```
c u t e o j s h u f d c
s d s k q e s r h n o p
p z r t o w e r f f u x
y o h y t w f f x u p
n i a r s f a i r i e s
d a s a d t n q n l q v
t x r d s c x a r q
e p c c e r o l k l o f
s x s a i l k u y v r n
x d m v j s l x z d r f
k e t e r g u l j a i f
s a a o z s o m m h m b
```

128